CATCH
A
CLOUD
—— HAWAII ——

Janice McEwan

Archway Publishing books may be ordered through booksellers or by contacting:

Archway Publishing
1663 Liberty Drive
Bloomington, IN 47403
www.archwaypublishing.com
844-669-3957

Interior Image Credit: Janice McEwan

ISBN: 978-1-6657-1734-2 (sc)
ISBN: 978-1-6657-1733-5 (e)

Library of Congress Control Number: 2022901621

Print information available on the last page.

Archway Publishing rev. date: 01/27/2022

GRATEFUL FOR

Jennifer, Mike, and Stephen who patiently wait and support me while I take that photo!

My friends and family for their encouragement.

Rae Gorman who encouraged me to create such a book.

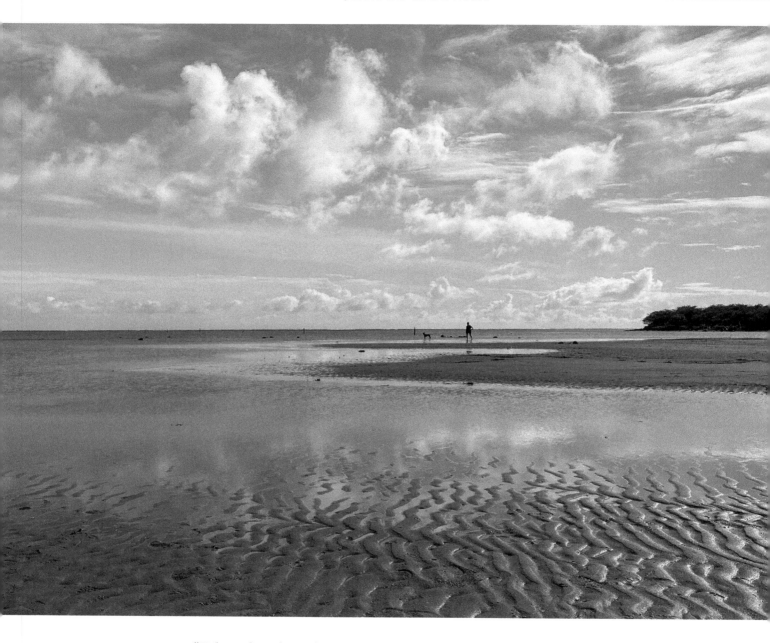

"Take a deep breath, smell the sea. Look up, feel the sky. Close your eyes and let your soul and spirit fly!" Janice McEwan

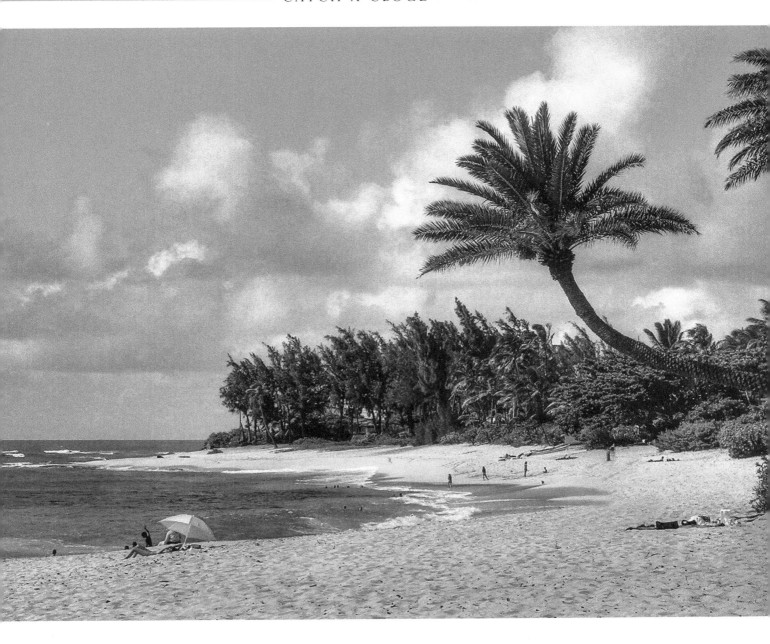

"In some ways, climbing in the clouds is comforting. You can no longer
see how high off the ground you are." Tommy Caldwell

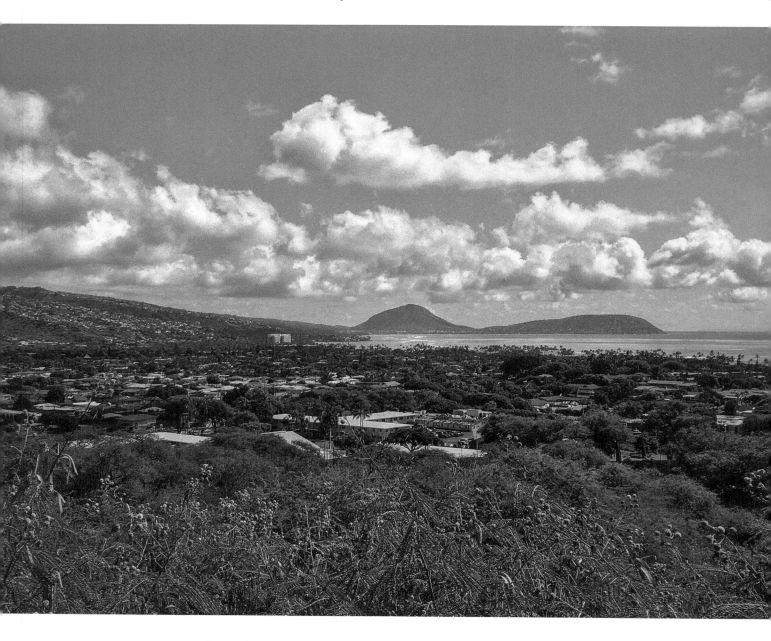

"The sky is an infinite movie to me. I never get tired of looking
at what's happening up there." K. D. Lang

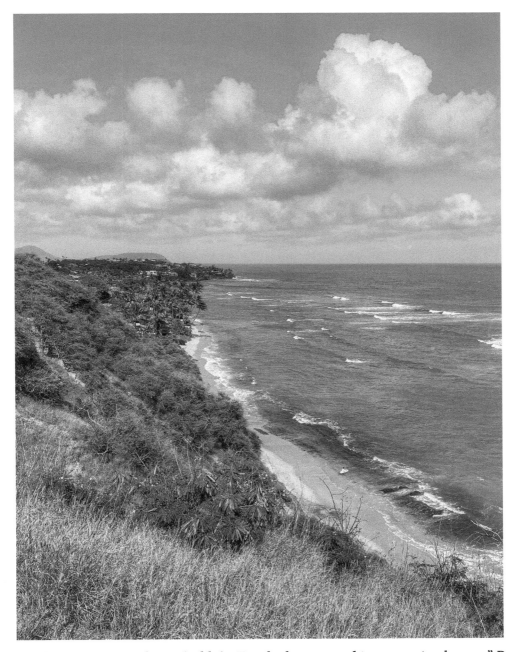

"Don't sit and wait. Get out there, feel life. Touch the sun and immerse in the sea." Rumi

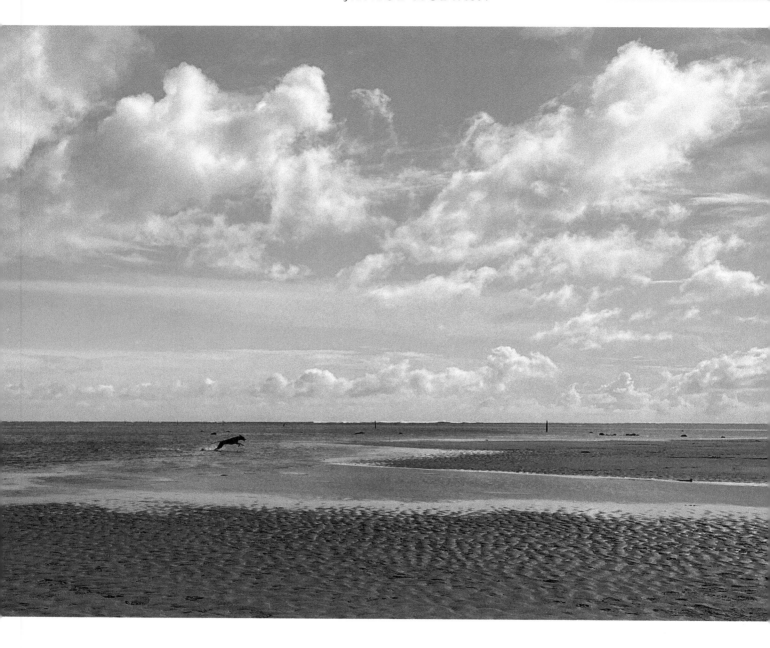

"I'd just like to run and dance with those clouds." Janice McEwan

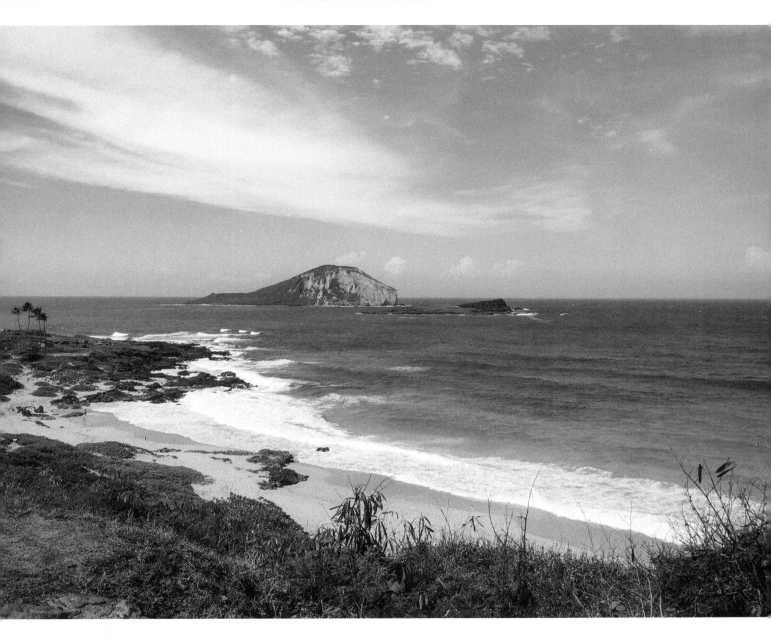

"If you want to relax, watch the clouds pass by if you're laying in the grass, or sit in front of the creek; just doing nothing and having those still moments is what rejuvenates the body." Miranda Kerr

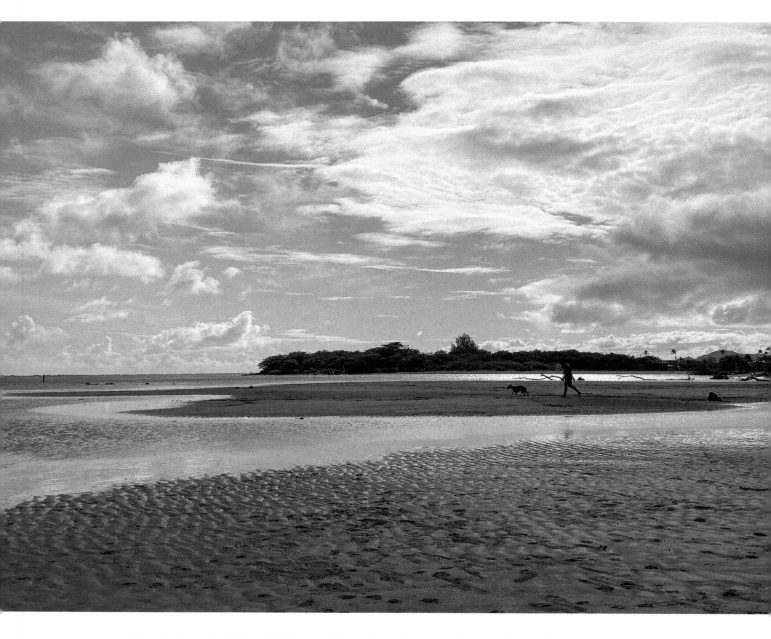

"At the beach, life is different. Time doesn't move hour to hour, but mood to moment. We live by the currents, plan by the tides and follow the sun." Sandy Tingras

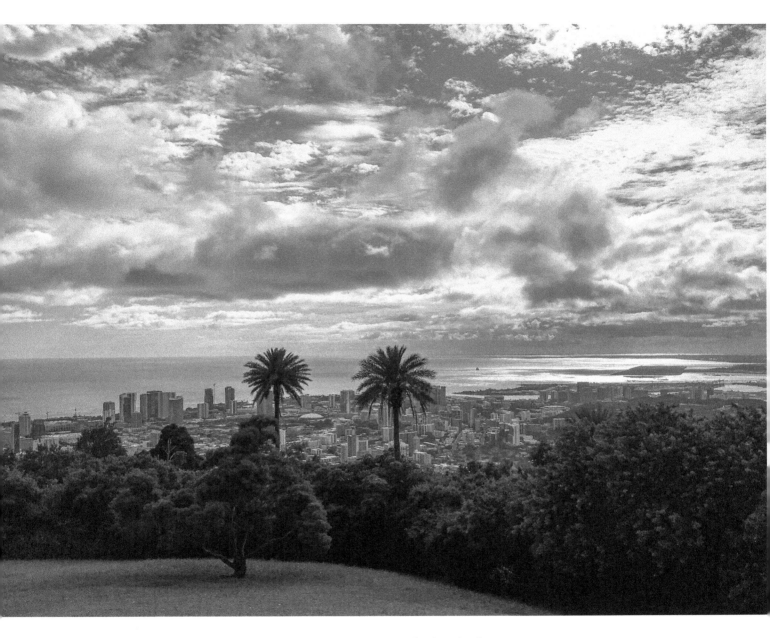

"Only from the heart can you touch the sky." Rumi

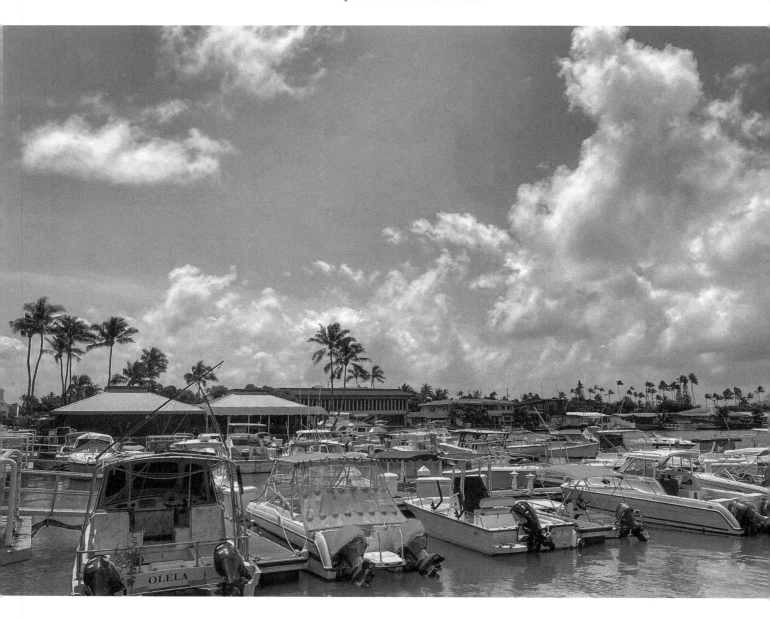

"Twenty years from now you will be more disappointed by the things you didn't do than by the ones you did do. So throw off the bowlines. Sail away from the safe harbor. Catch the trade winds in your sails. Explore. Dream. Discover." H. Jackson Brown Jr.

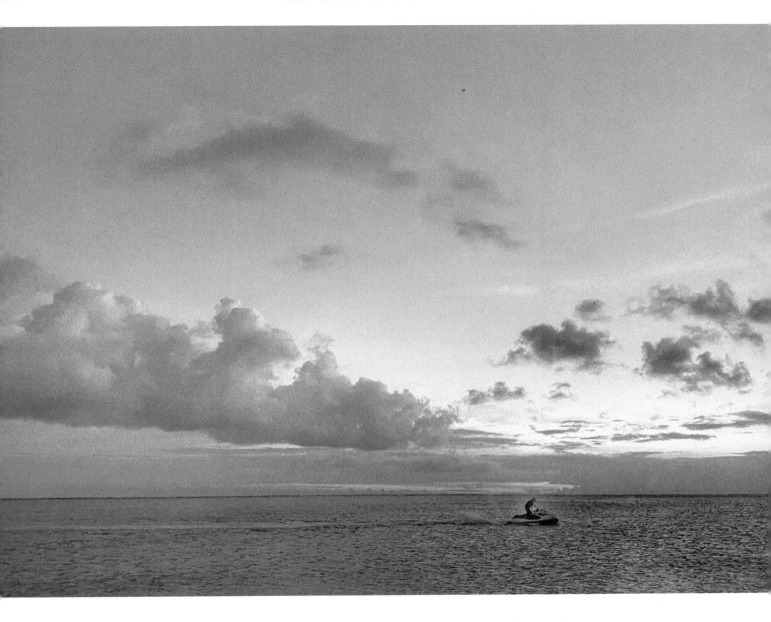

"The color has faded out of the sky. It's grey becoming darker as the world turns herself round a little more. The clouds are long and black and ragged like the wings of storm-battered dragons." Keri Hulme

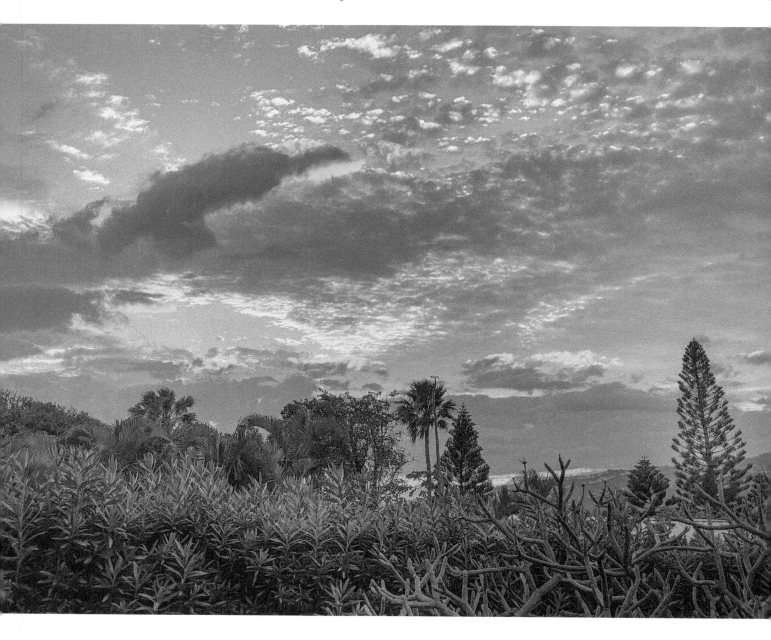

"Sometimes the west showed clouds like tiny pink feathers; sometimes it showed purple mountains and green lakes; sometimes the clouds were scarlet with gold around the edges." Maud Hart Lovelace

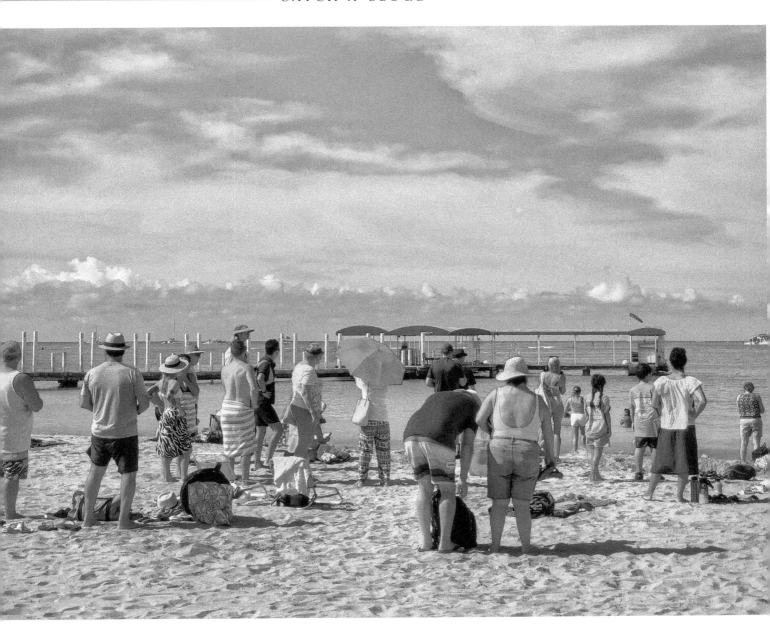

"Patience is not simply the ability to wait—it's how we behave while we're waiting." Joyce Meyer

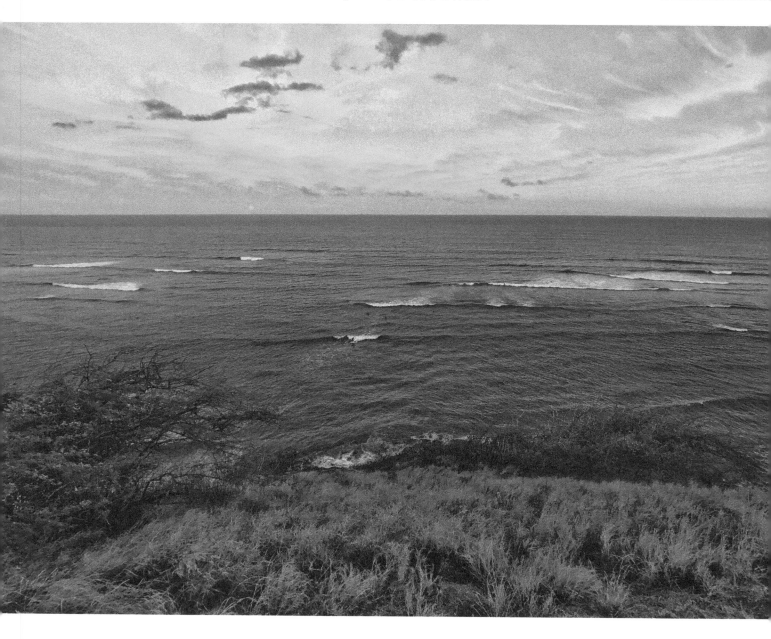

"I'd like to just get one of those pink clouds and put you in
it and push you around." F. Scott Fitzgerald

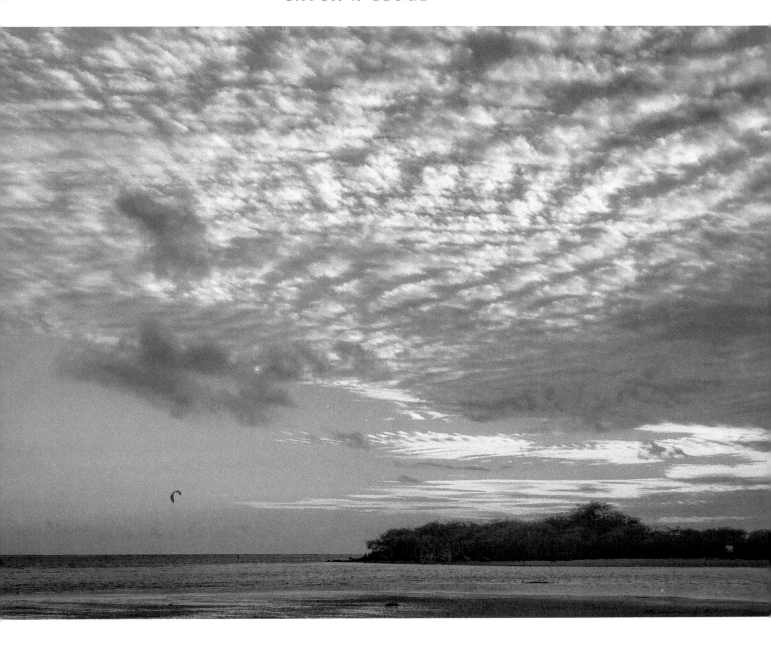

"The ripples within the clouds shall lead us to the beach in the sky." Anthony T. Hincks

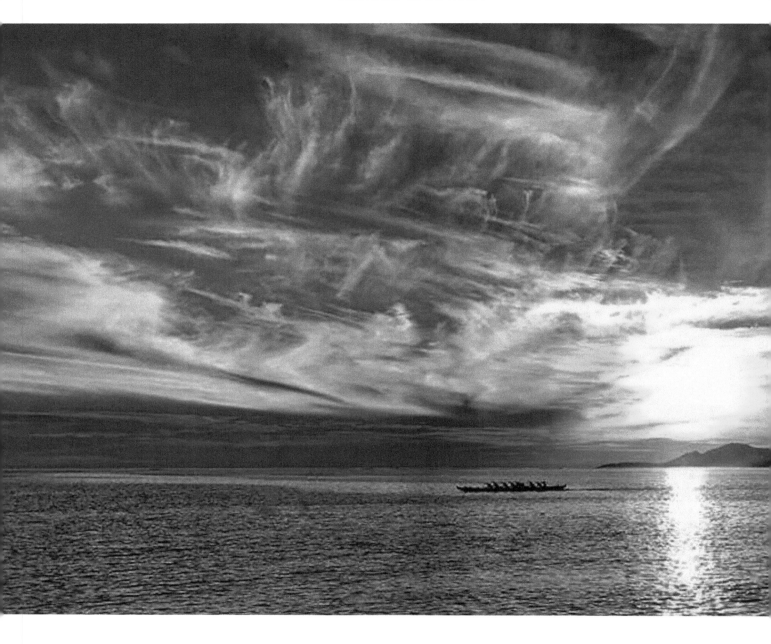

"Once you have tasted the taste of sky, you will forever look up." Leonardo da Vinci

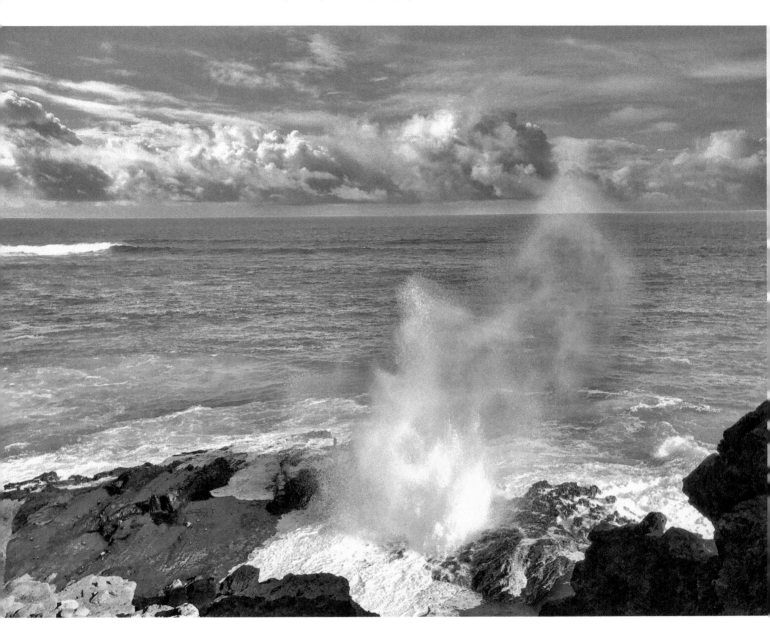

"Dream higher than the sky and deeper than the ocean." Monica Paul

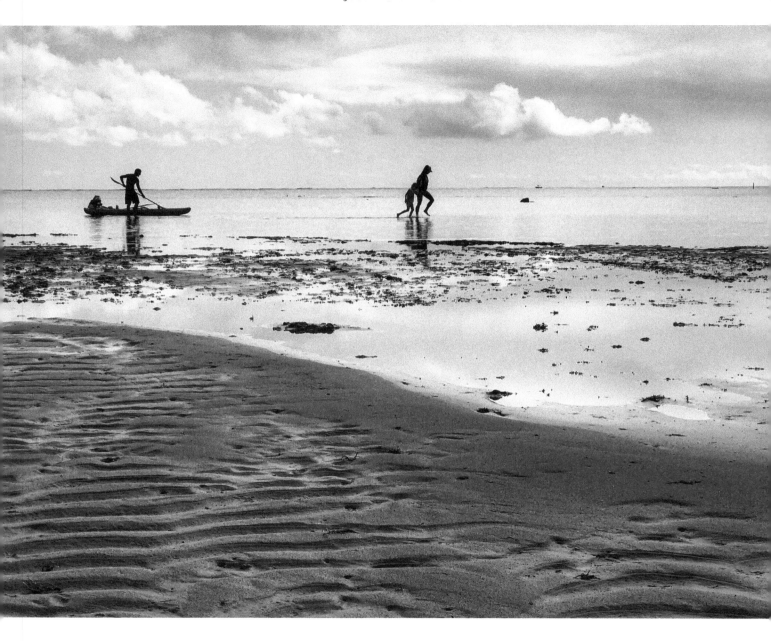

"When you arise in the morning, think of what a precious privilege it is to be alive —
to breathe, to think, to enjoy, to love—then make that day count." Steve Maraboli

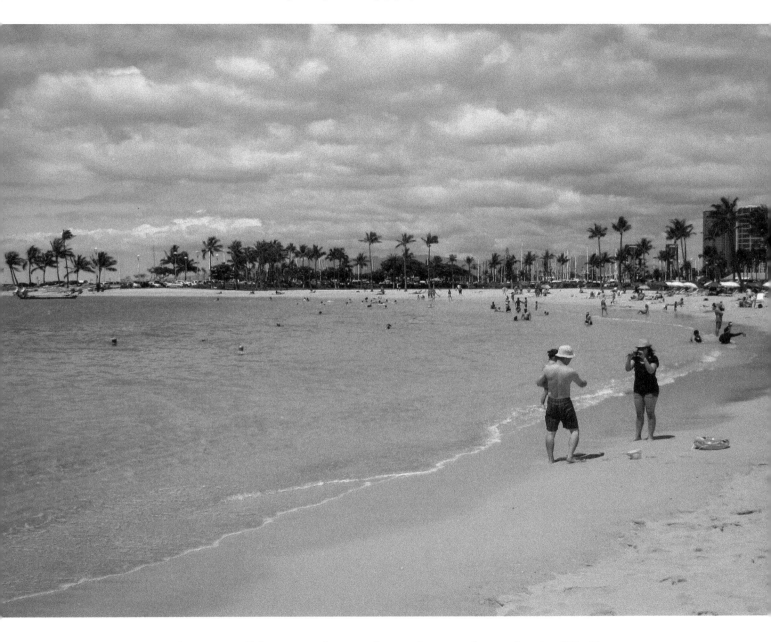

"It is essential to our well-being, and to our lives, that we play and enjoy life. Every single day do something that makes your heart sing." Marcia Wieder

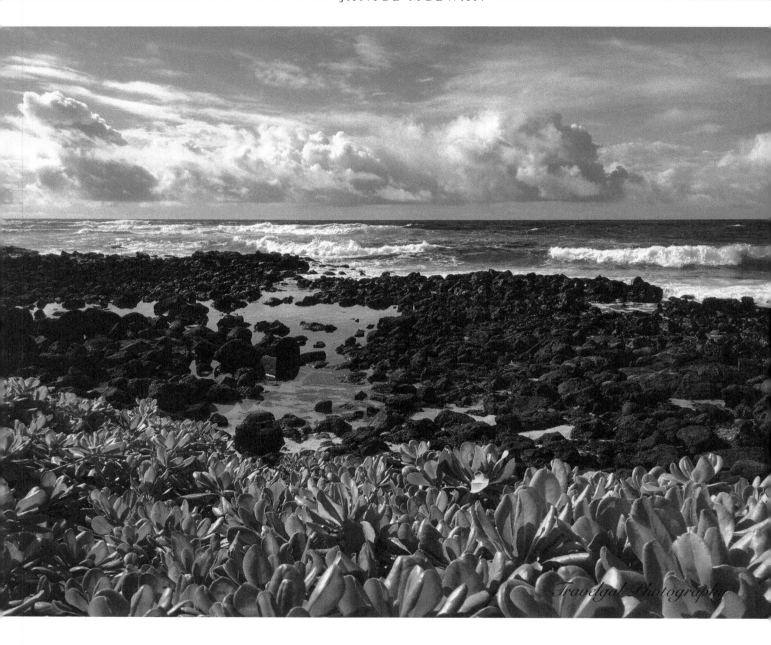

"There are divine things more beautiful than words can tell." Walt Whitman

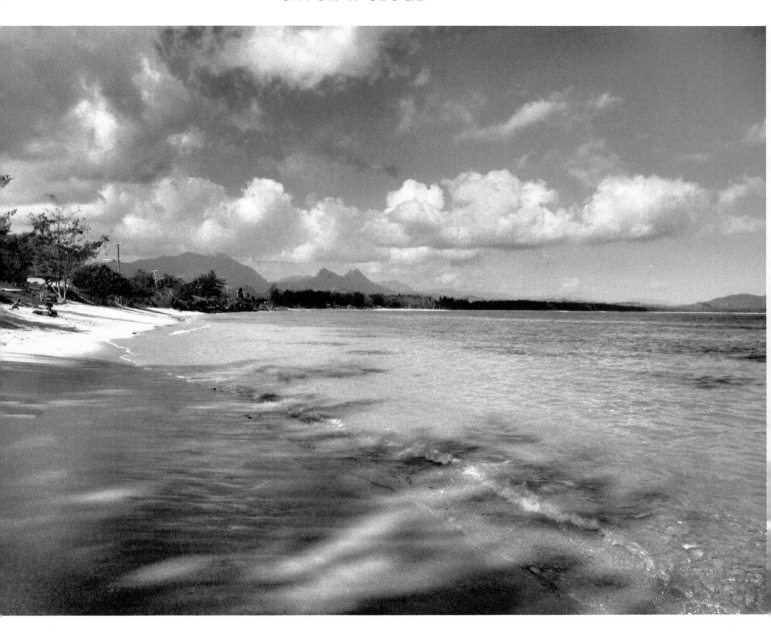

"My soul dances among the clouds. I am truly alive." Trudy V

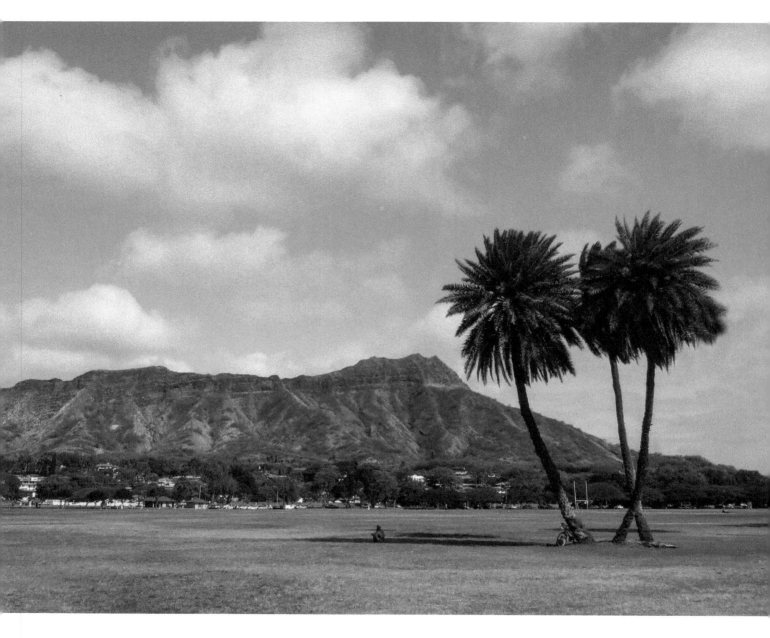

"Meditation is like giving a hug to ourselves, getting in touch with that awesome reality in us. While meditating we feel a deep sense of intimacy with God, a feeling that is inexplicable." Yogananda

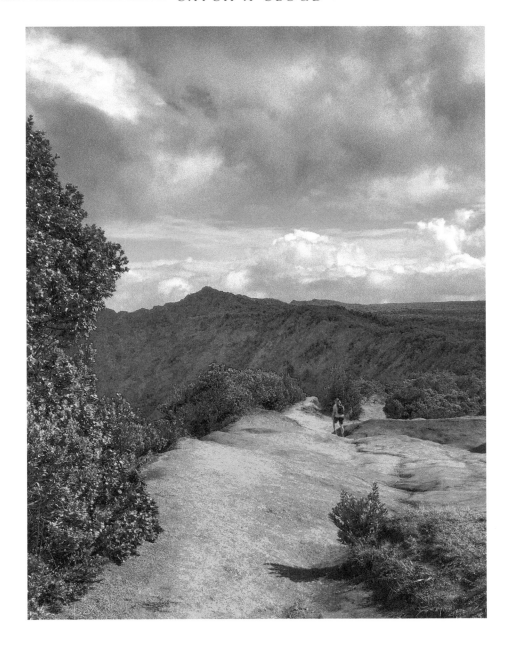

"Sometimes you just need a break. In a beautiful place, Alone. To figure out everything." Ambuj Sony

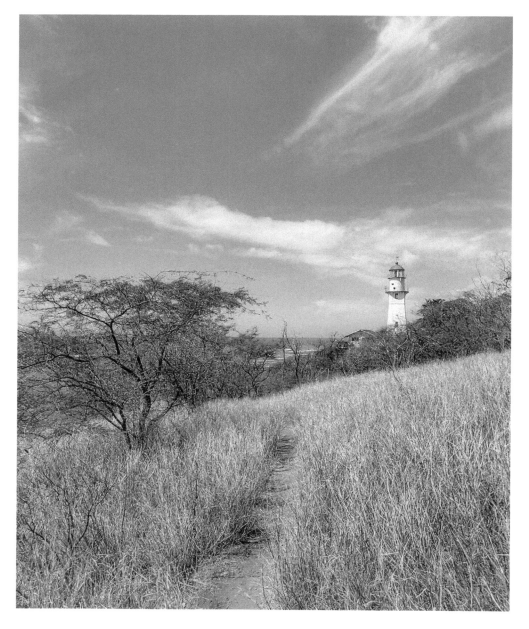

"If you open your eyes very wide and look around you carefully, you will always see a lighthouse which will lead you to the right path! Just watch around you carefully." Mehmet Murat Ildan

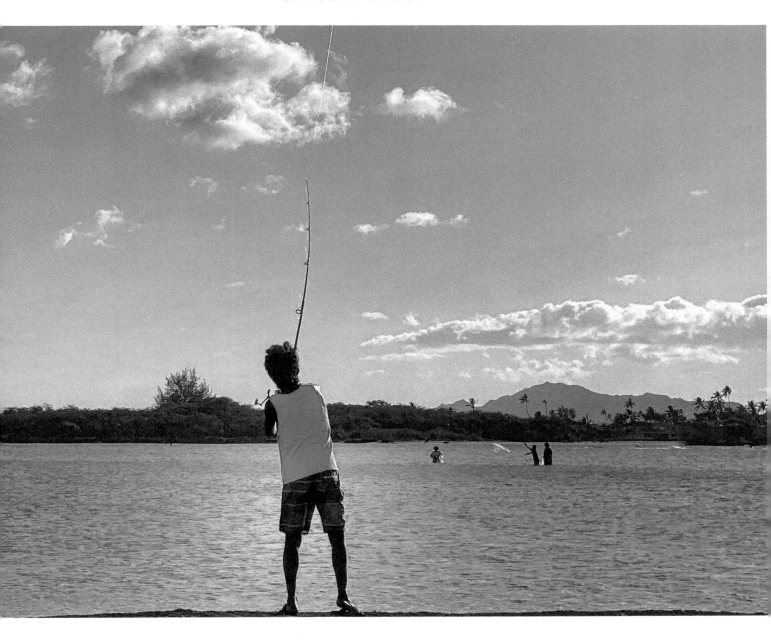

"Catch a cloud." Janice McEwan

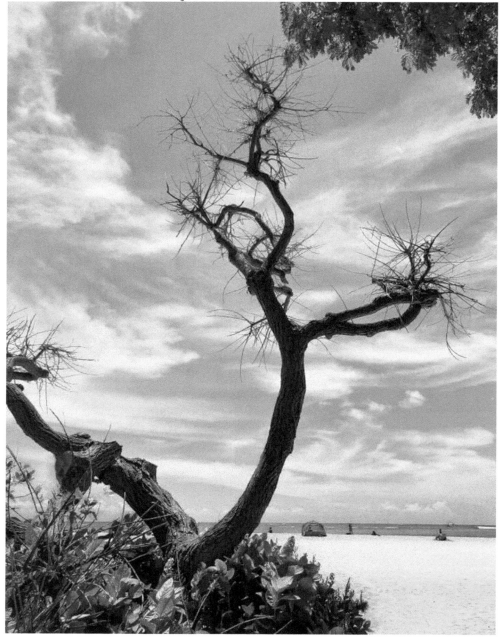

"Be like a tree and let the dead leaves drop." Rumi

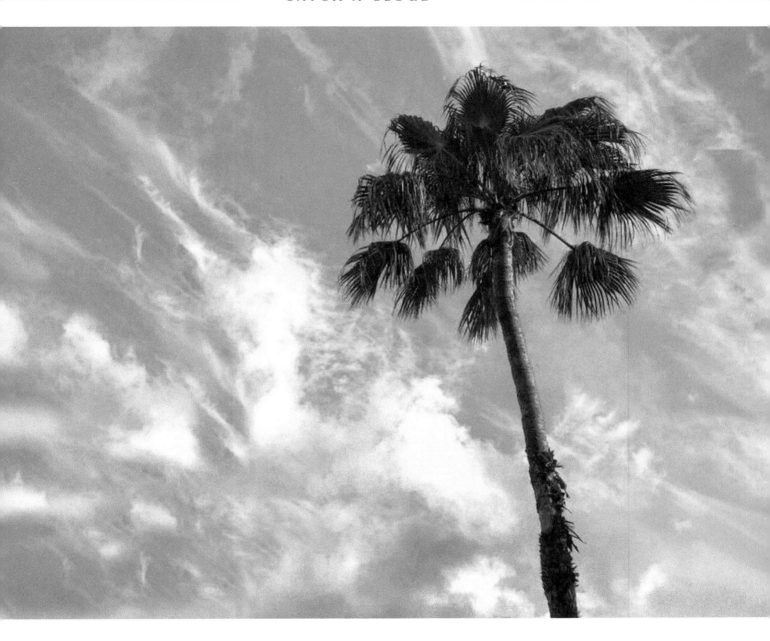

"For one minute, walk outside, stand there, in silence, look up at the sky, and contemplate how amazing life is." Rhonda Byrne

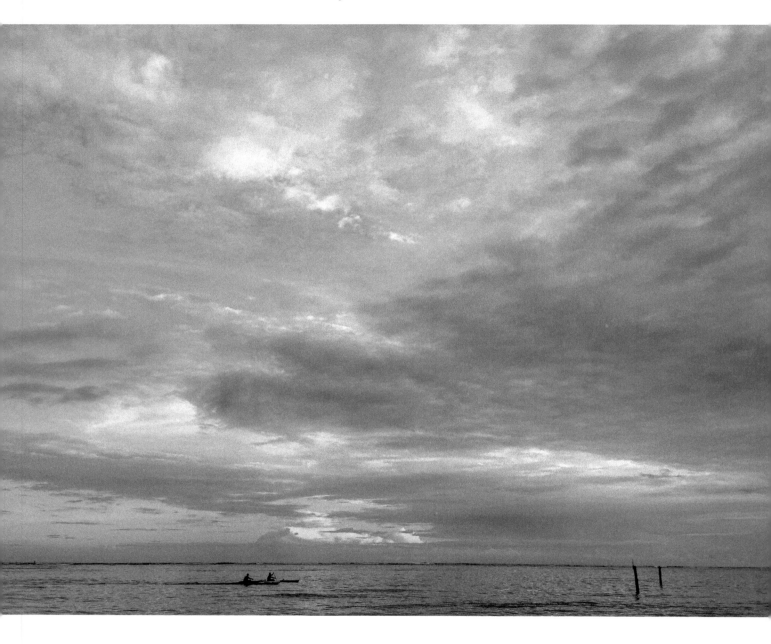

"You must not blame me if I talk to the clouds." Henry David Thoreau

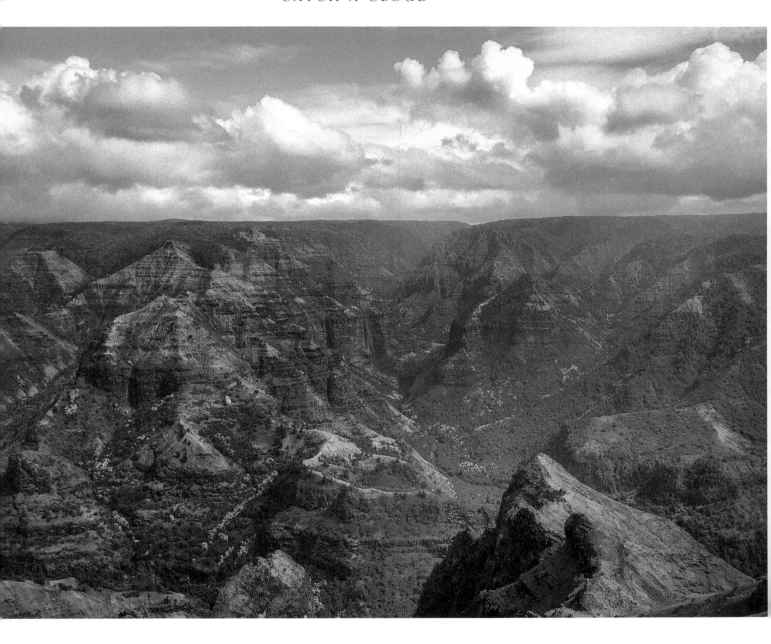

"May your trails be crooked, winding, lonesome, dangerous, leading to the most amazing view. May your mountains rise into and above the clouds." Edward Abbey

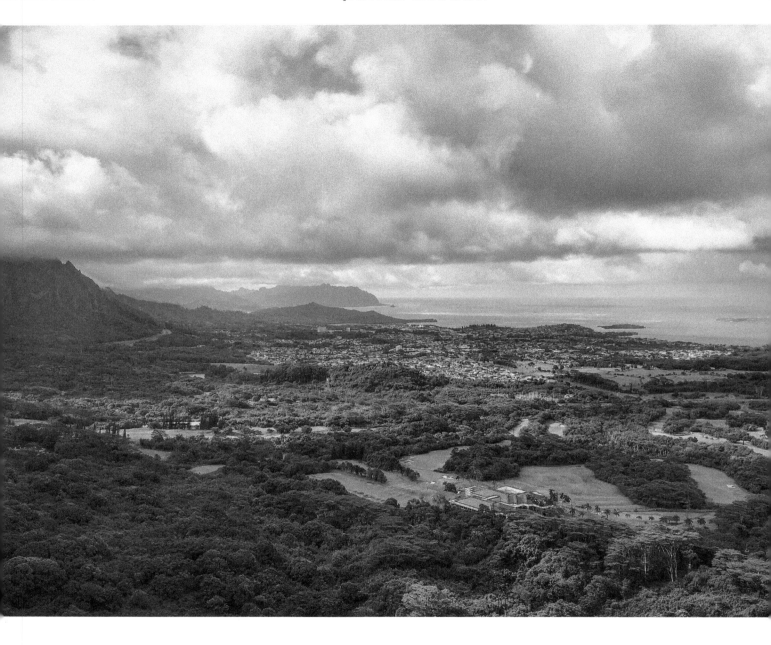

"Life isn't about waiting for the storm to pass…it's about learning to dance in the rain." Vivian Greene

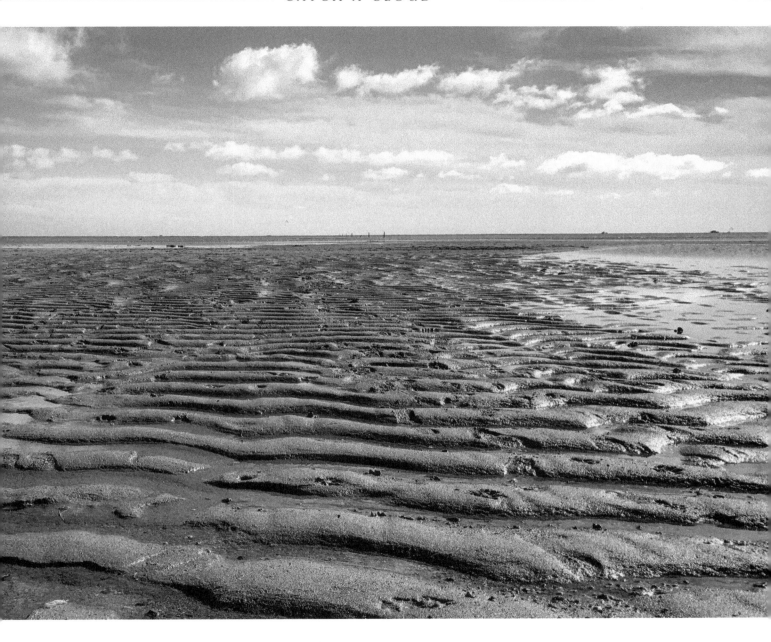

"Sky above, sand below, peace within." Katrina Kaif

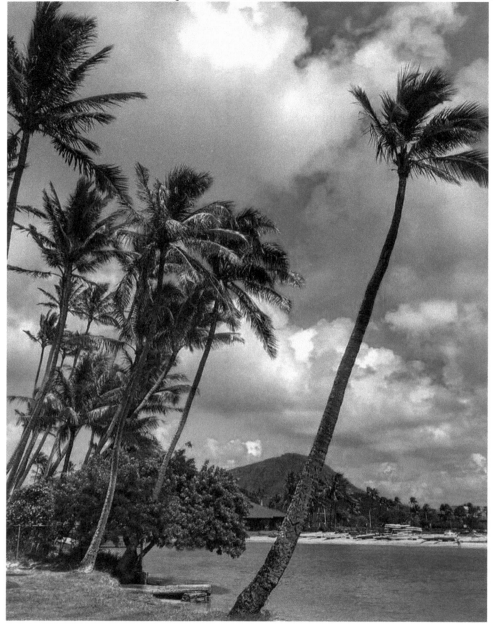

"Live quietly in the moment and see the beauty of all before you.
The future will take care of itself." Yogananda

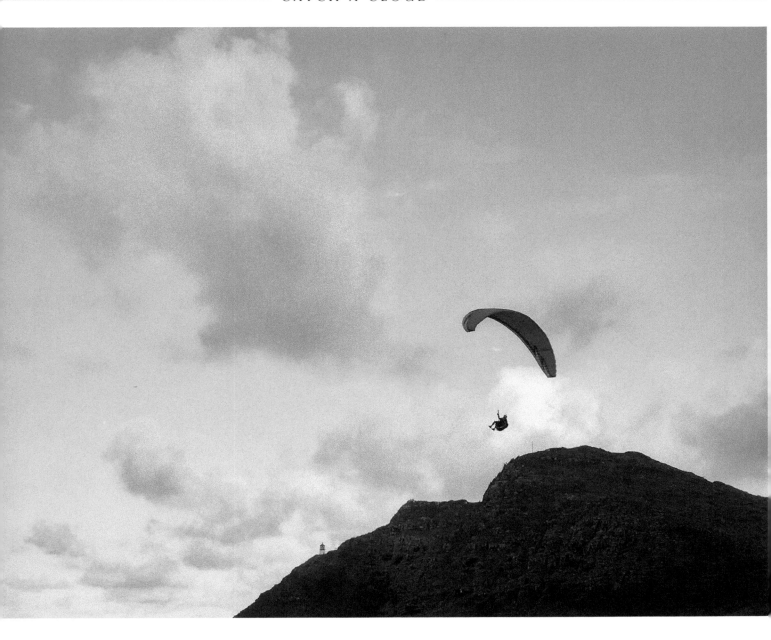

"When you're forced to stand alone, you realize what you've got in you." Uma Thurman

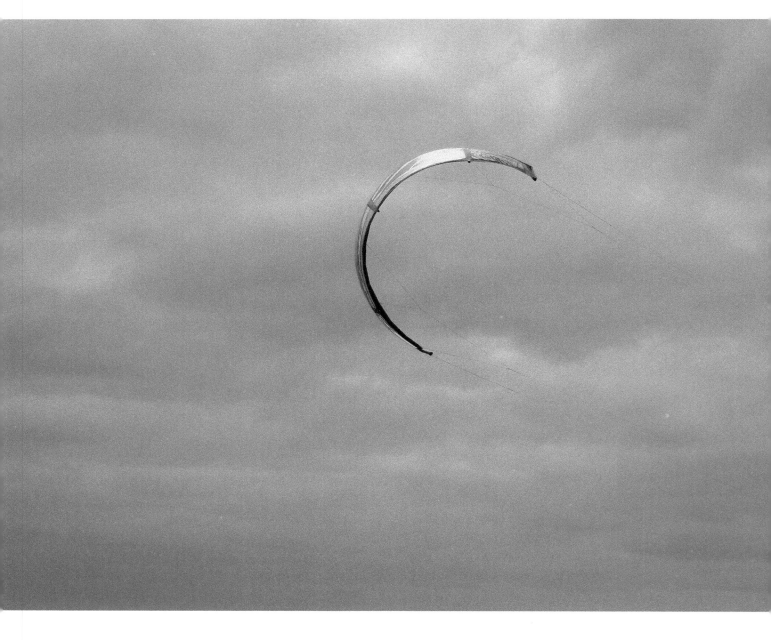

"Catch a cloud." Janice McEwan

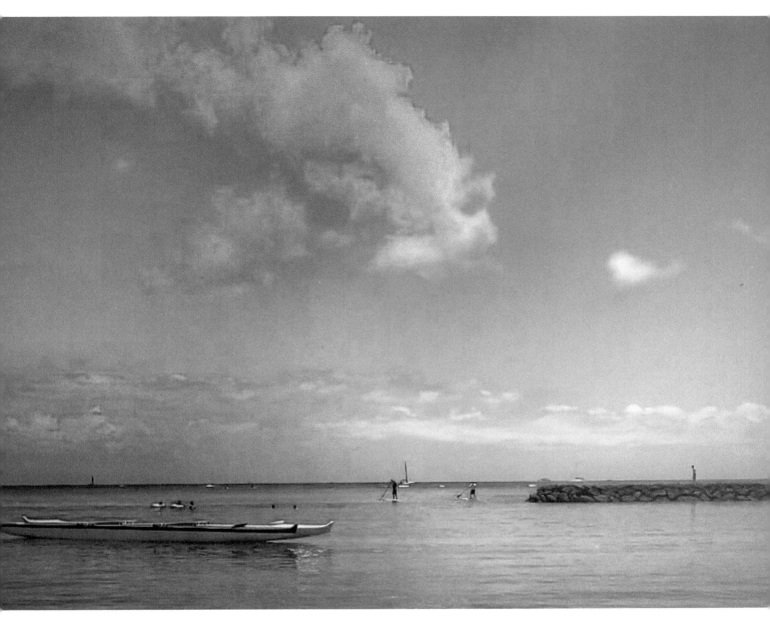

"Look past your thoughts so you may drink the pure nectar of this moment." Rumi

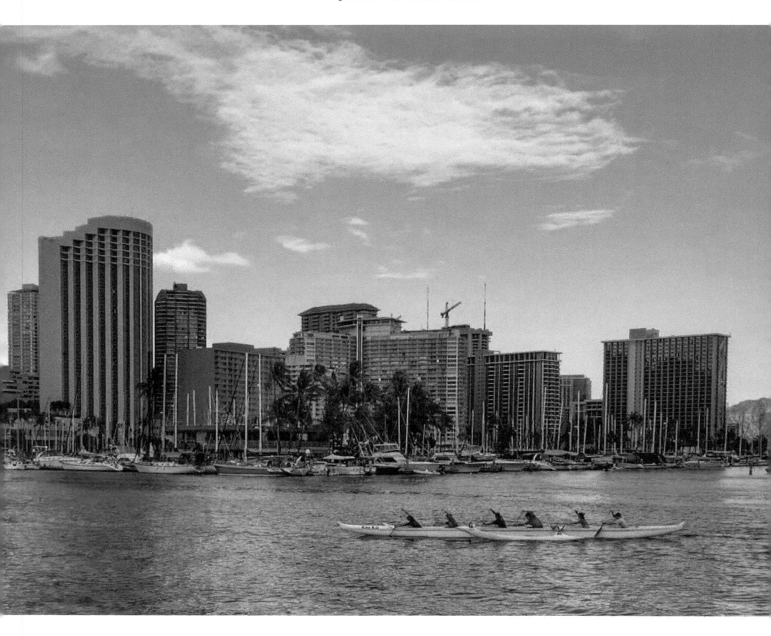

"Individually we are one drop. Together we are an ocean." Ryunosuke Satori

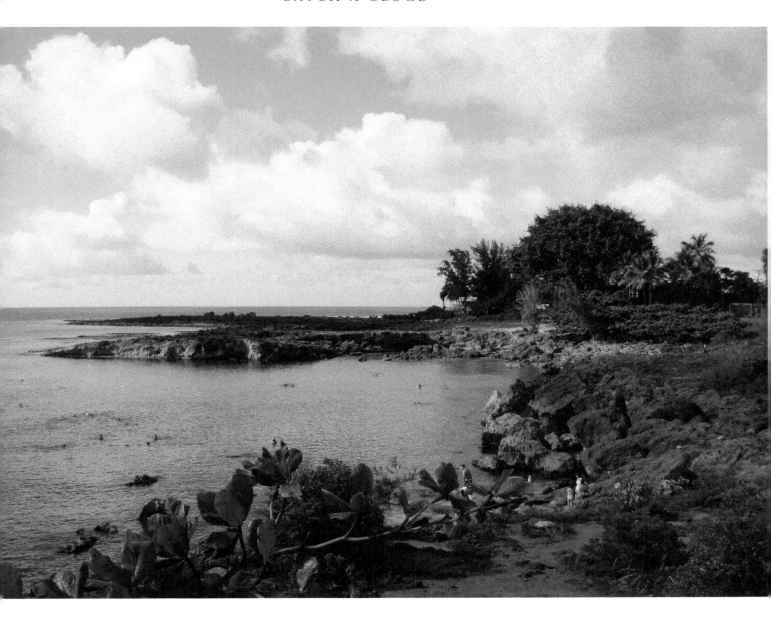

"Man's great need is to find time to enjoy nature, to simplify his life and his imaginary necessities, to enjoy the true needs of his existence, to learn to know his children and friends better, and most of all, to know himself and the God who made him." Yogananda

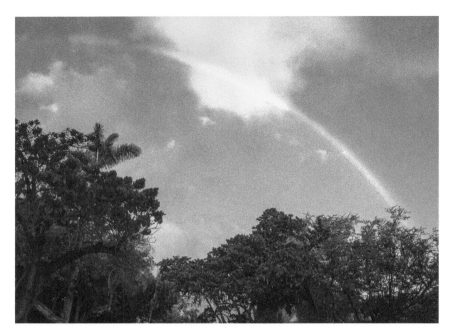

"Don't let a dark cloud

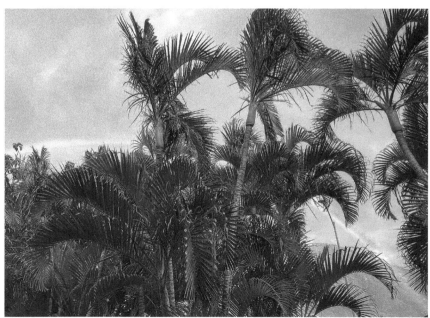

hide your rainbow."
Janice McEwan

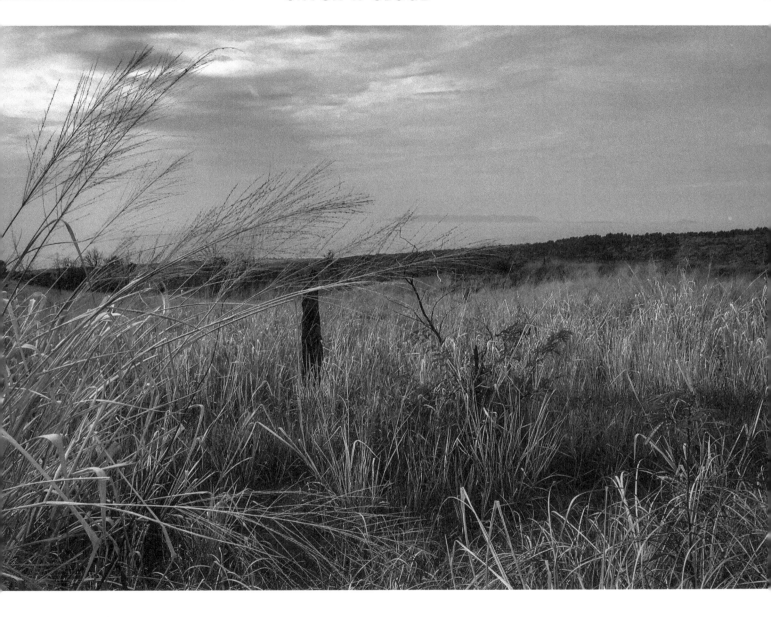

"If the sight of the blue skies fills you with joy, if a blade of grass springing up in the fields has power to move you, if the simple things of nature have a message that you understand, rejoice, for your soul is alive." Eleonora Duse

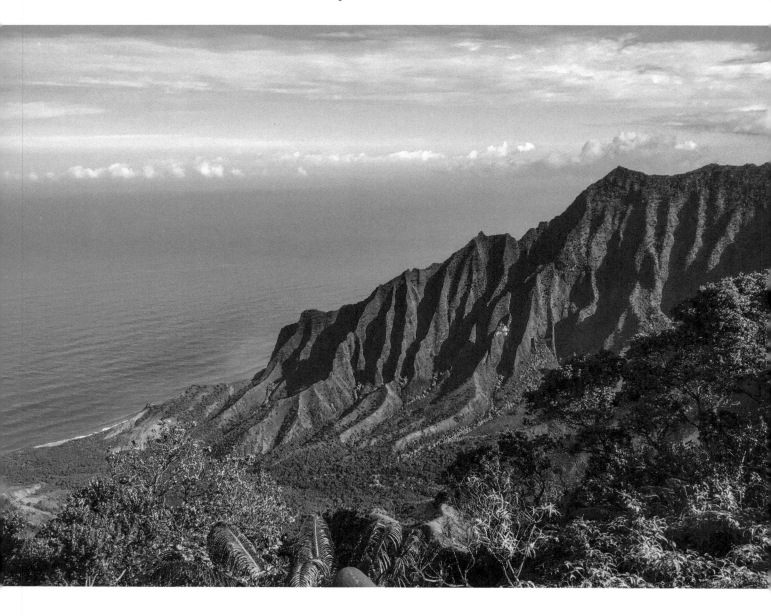

"Men go abroad to wonder at the heights of mountains, at the huge waves of the sea, at the long courses of the rivers, at the vast compass of the ocean, at the circular motion of the stars, and they pass by themselves without wondering." St. Augustine

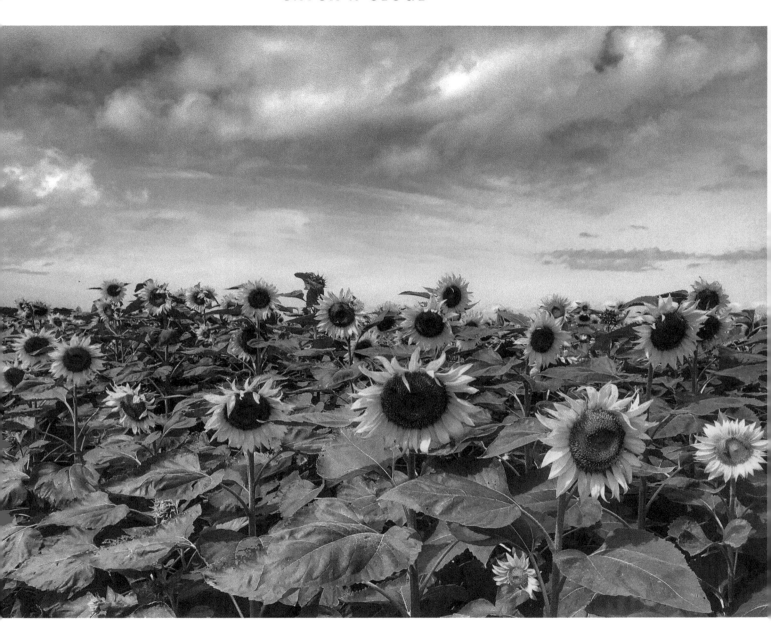

"In a meadow full of flowers, you cannot walk through and breathe those smells and see all those colors and remain angry. We have to support the beauty, the poetry of life." Jonas Mesas

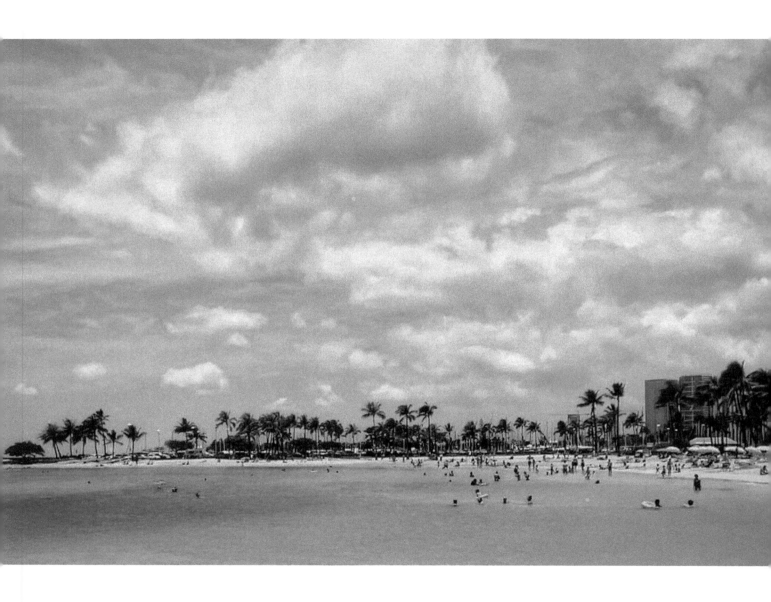

"The sand may brush off. The salt may wash clean. The tans may fade. But the memories will last forever." Tonya Gunn

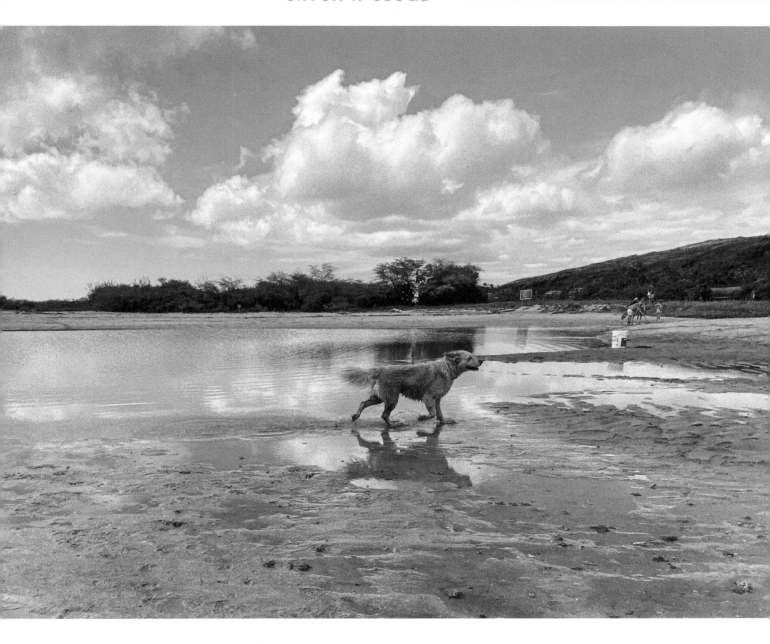

"Yesterday I soared above the clouds. Today I'll walk the earth again." Anthony T. Hincks

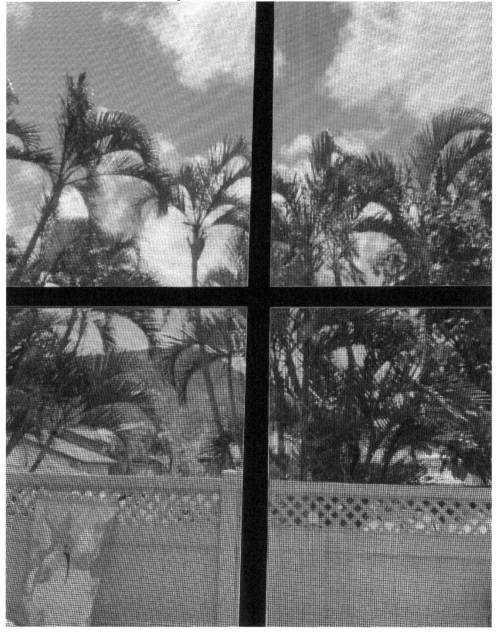

"Throw open the window and let the scenery of clouds and sky enter your room." Yosa Buson

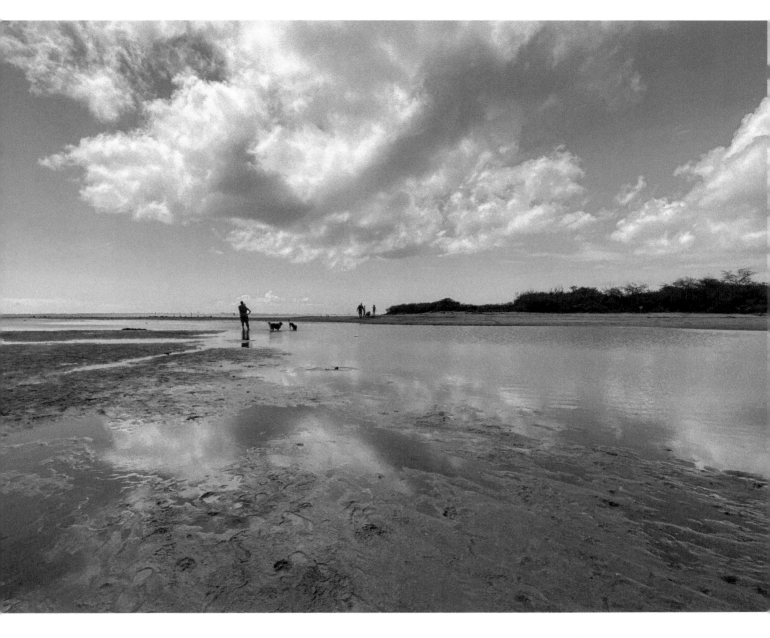

"Ever wonder where you'd end up if you took your dog for a walk and
never once pulled back on the leash?" Robert Breault

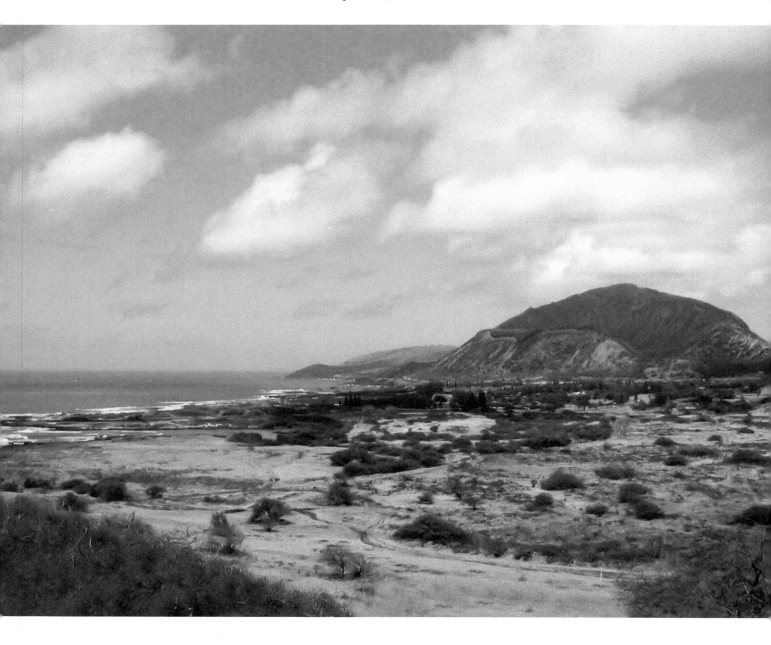

"The quieter you become the more you can hear." Ram Dass

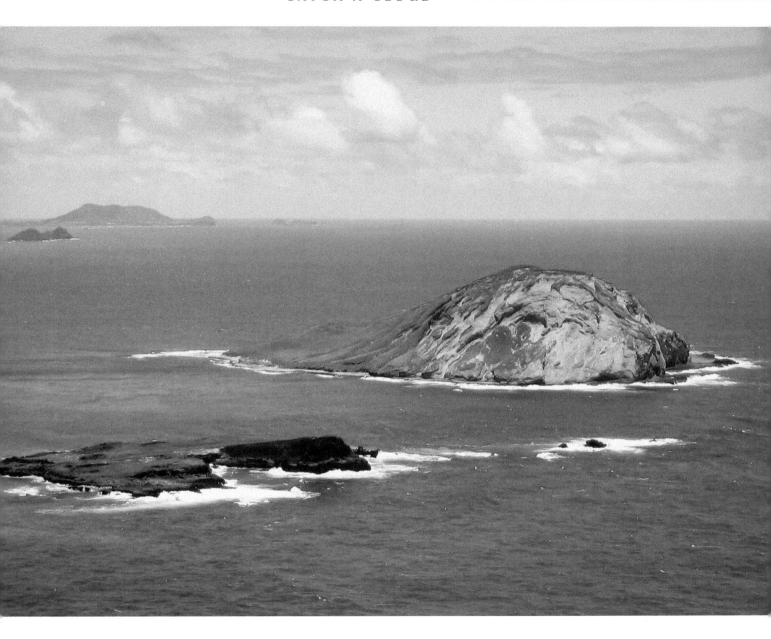

"God's in His heaven. All's right with the world." Robert Browning

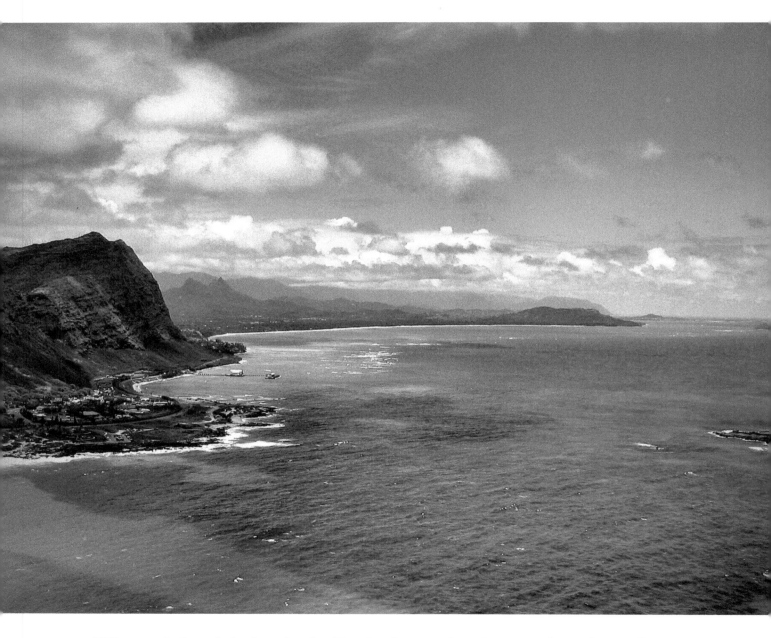

"When we feel stuck, look at the sky. The clouds remind us that everything changes." Agnes Nana

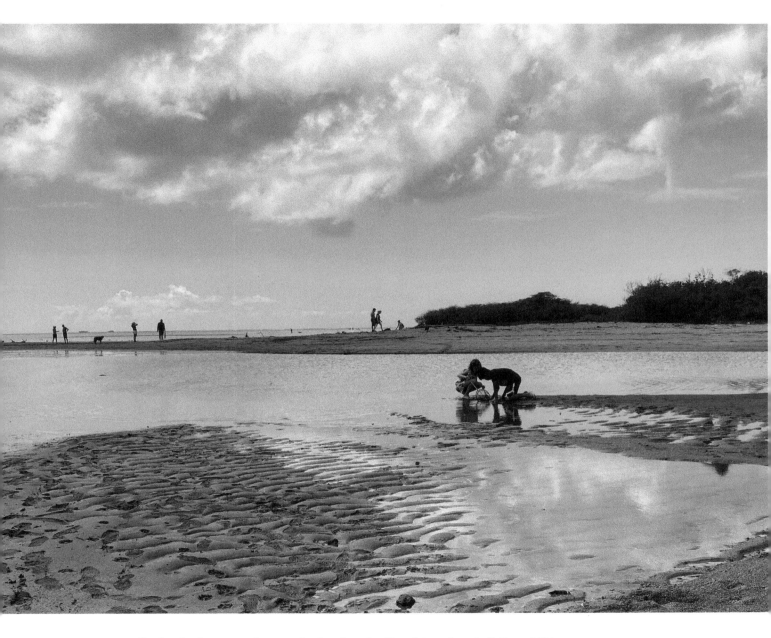

"I think the most heavenly food is fluffy white clouds." Jarod Kintz

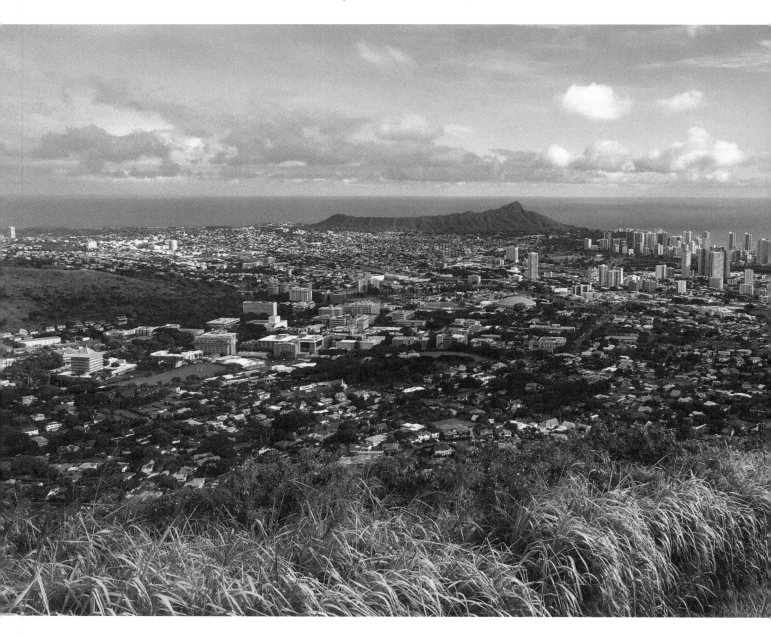

"I believe Hawaii is the most precious jewel in the world." Don Ho

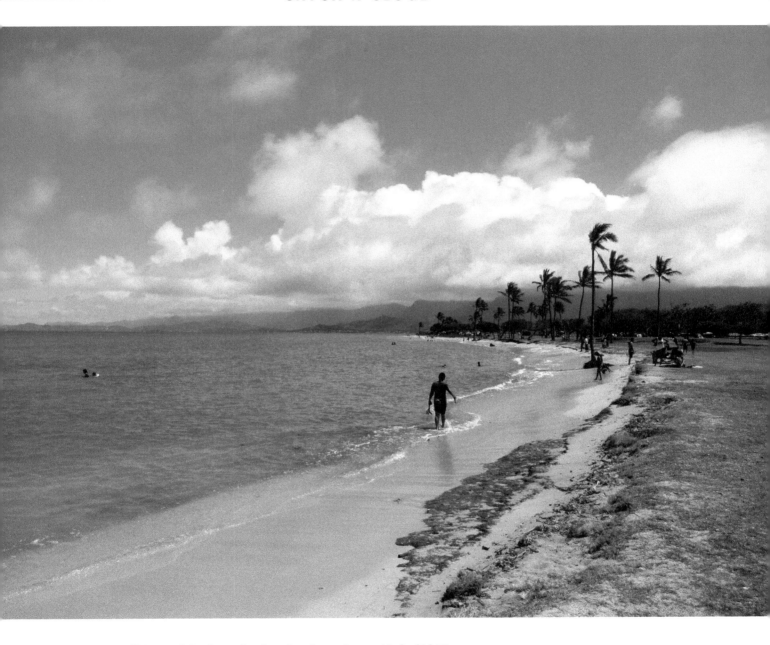

"Now, if God made the clouds so beautiful, did He not mean us to gaze upon them and be thankful for them." Alfred Rowland

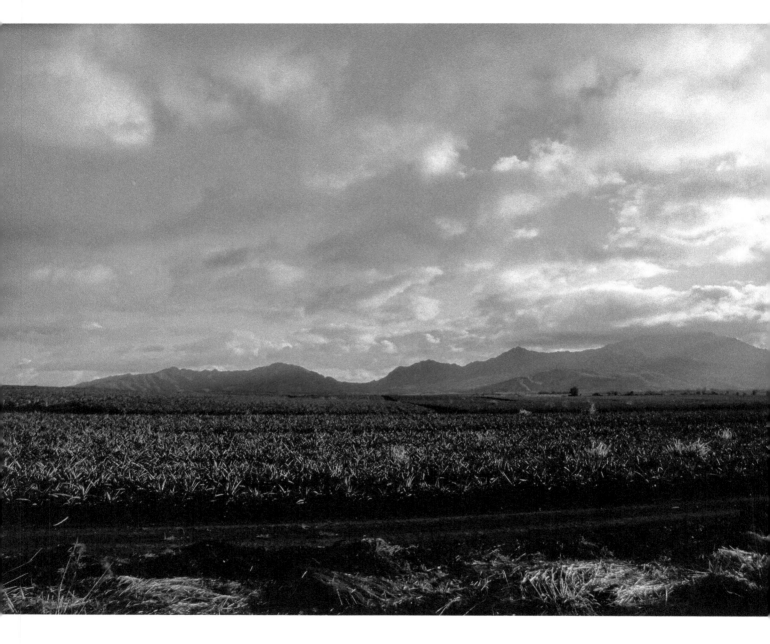

"Dark clouds become heaven's flowers when kissed by light." Miranda Kerr

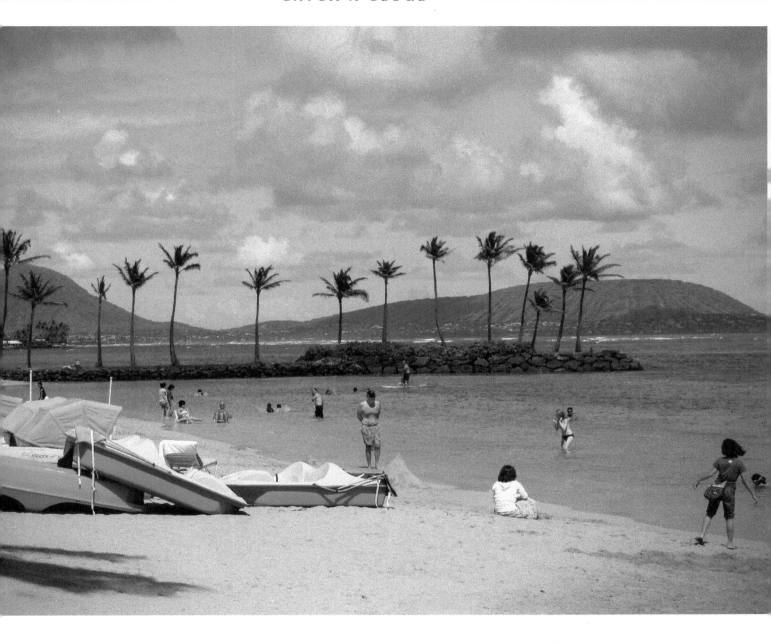

"If you use your imagination, you can see lots of things in the cloud formations." Charles M. Schulz

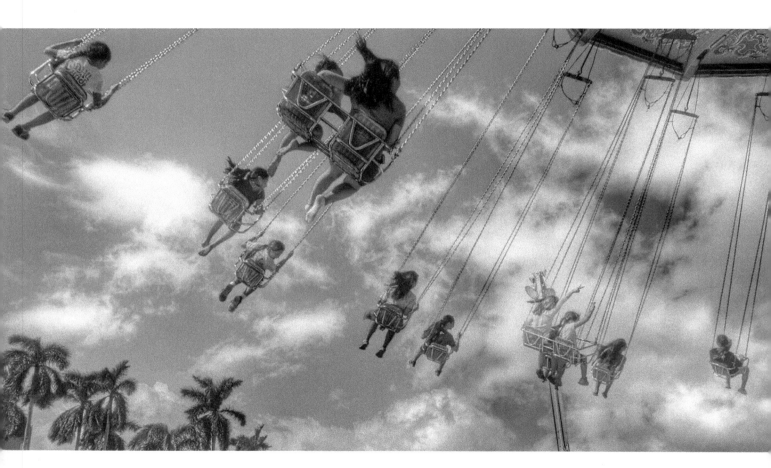

"Catch a cloud." Janice McEwan

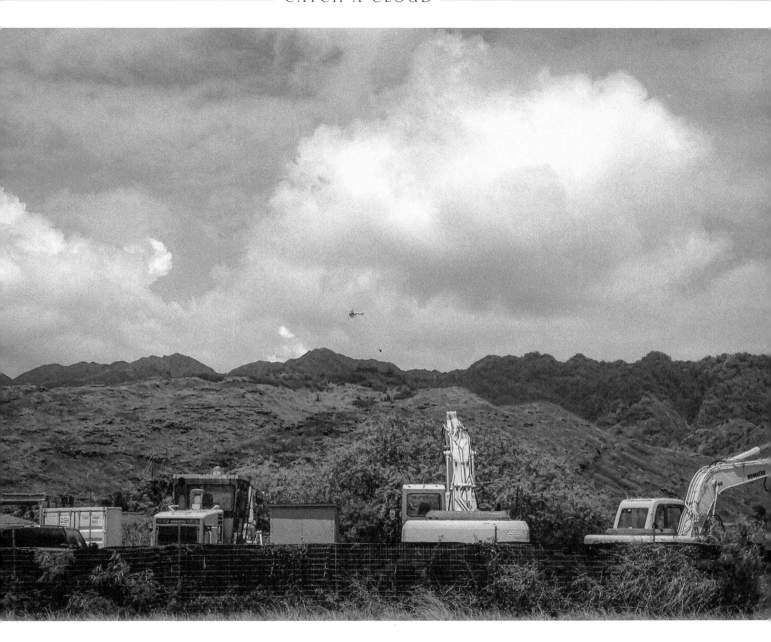

"I bow in reverence to the white cloud." Li Bai

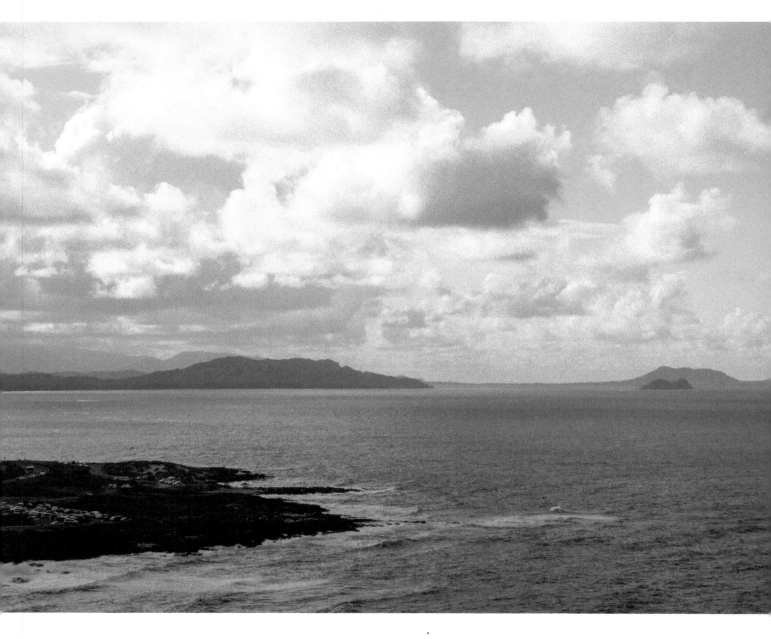

"Yesterday I inhaled a cloud, and immediately my eyes started raining." Jarod Kintz

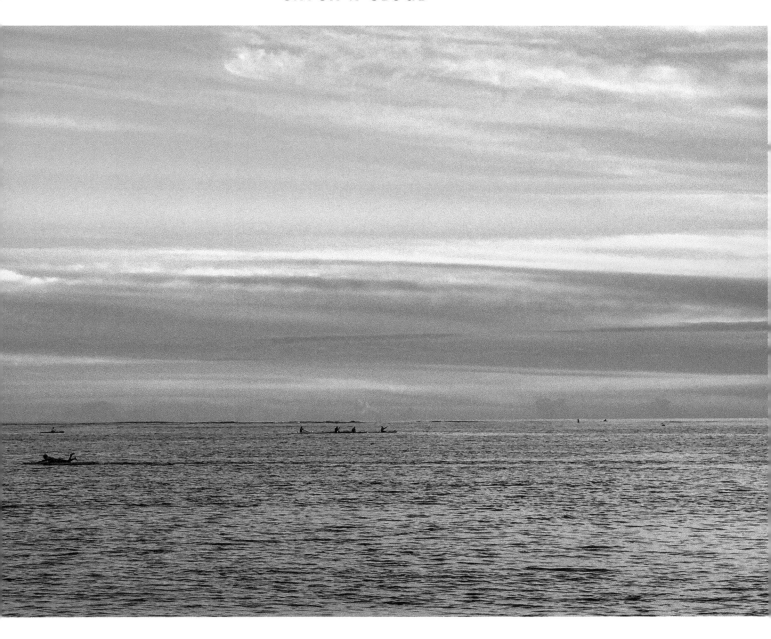

"Even when clouds grow thick, the sun still pours its light earthward." Mark Nepo

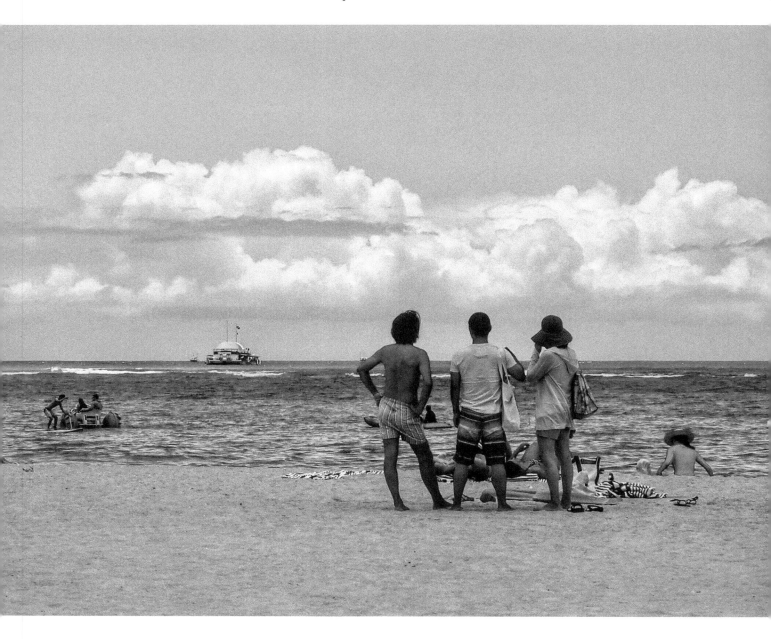

"Look at the sky. We are not alone. The whole universe is friendly to us and conspires only to give the best to those who dream and work." A. P. J. Abdul Kalam

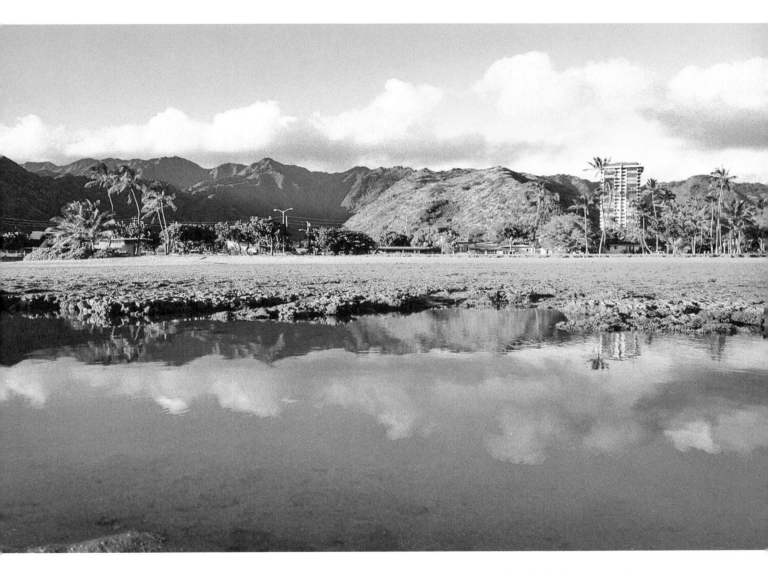

"A well and a lake fought over moon's reflection! But the cloud won the fight." Francis Koya

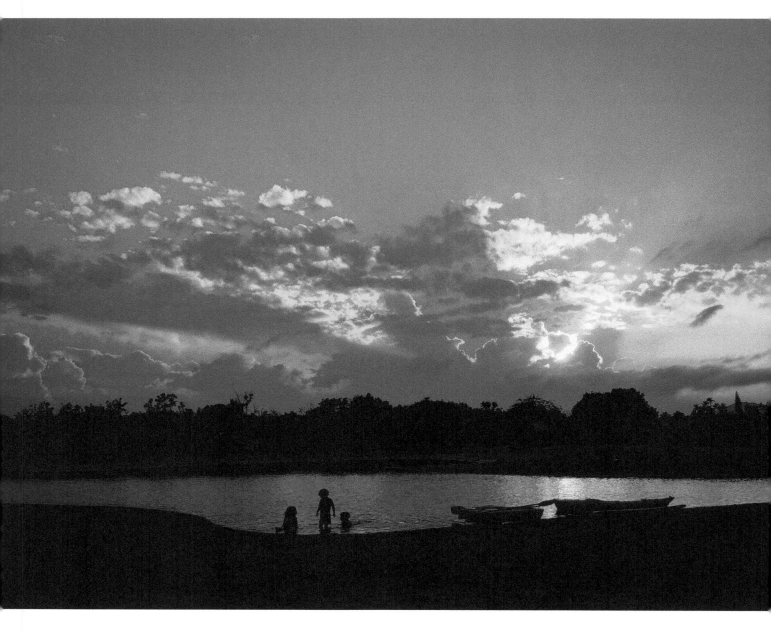

"We talk of sunshine and moonshine, but not of cloud-shine, which is yet one of the illuminations of our skies. A shining cloud is one of the most majestic of all secondary lights." Alice Meynell

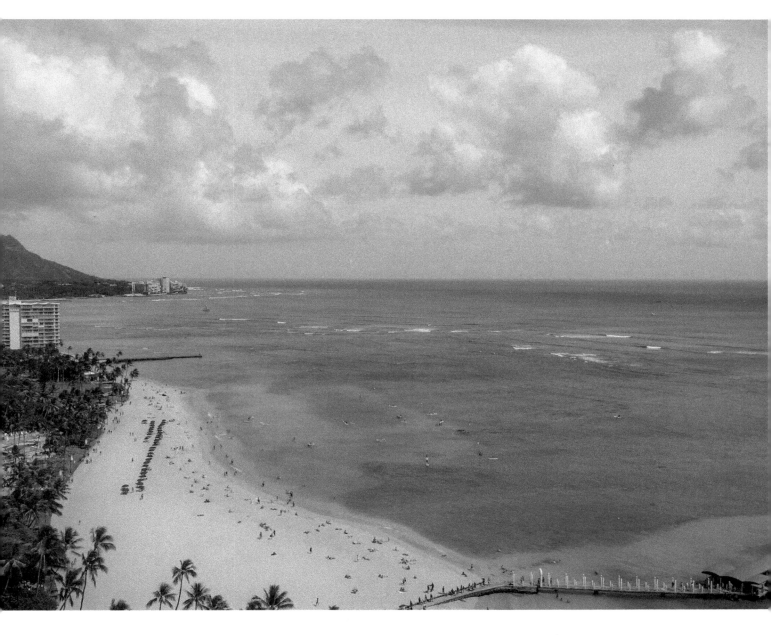

"Have you ever watched a cloud rushing off across the sky and wished that it would stay still?" Janice McEwan

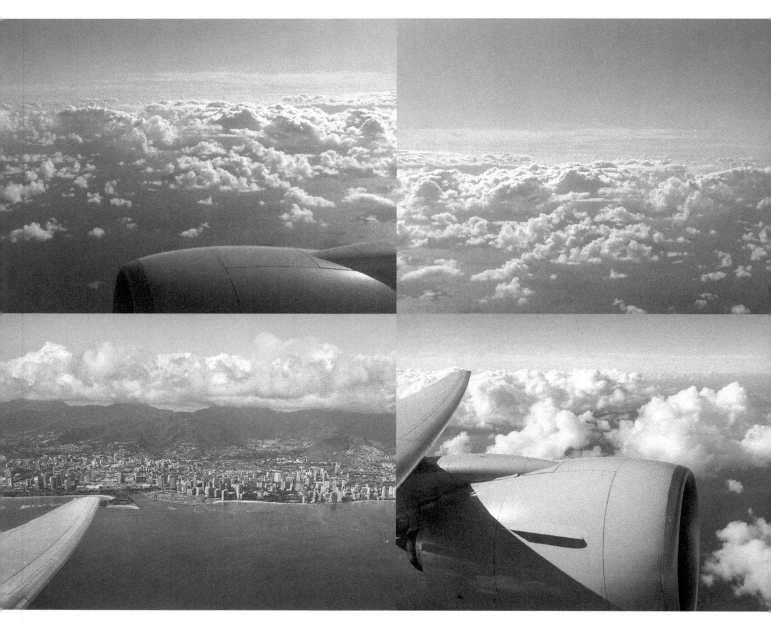

"In planes, I used to try to look behind the clouds to see if I saw an angel." Kerry Kennedy

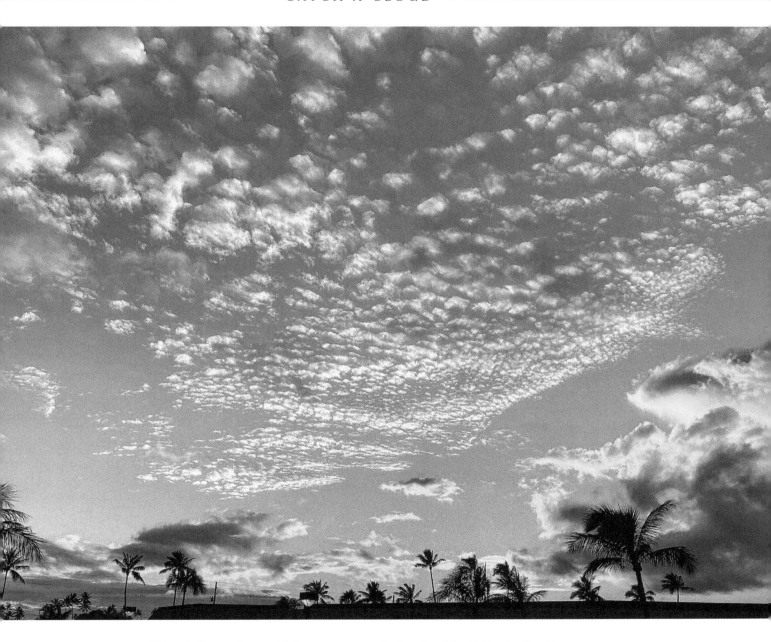

"Don't forget beautiful sunsets need cloudy skies." Paulo Coelho

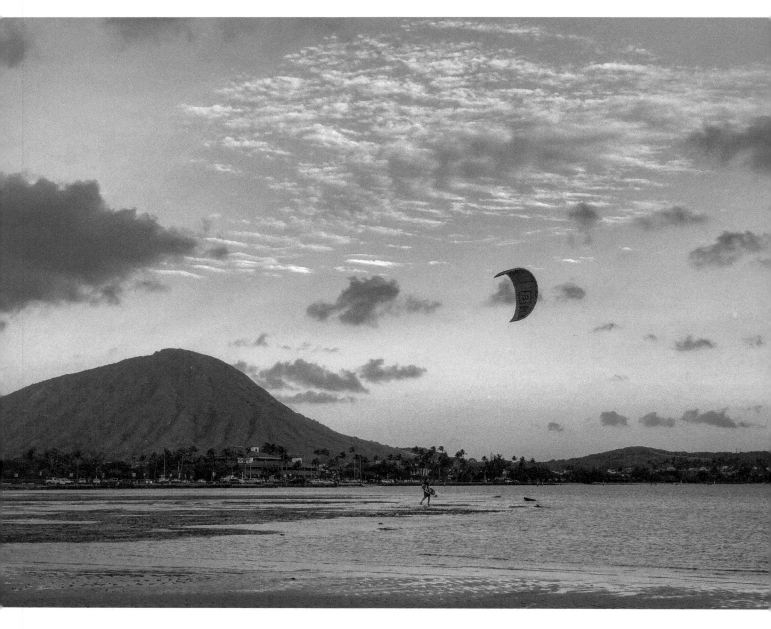

"Catch a cloud." Janice McEwan

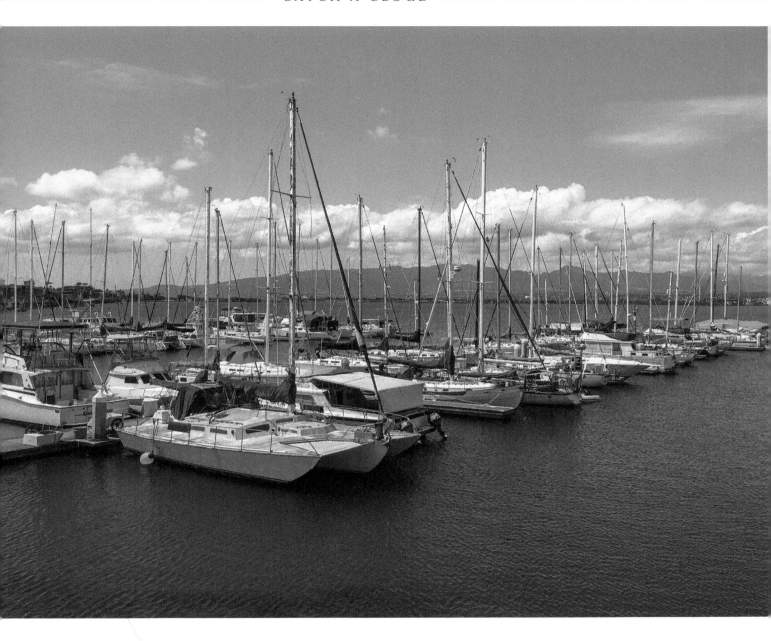

"Clouds in the sky very much resembles the thoughts in our minds! Both changes perpetually from one second to another." Mehmet Murat Ildan

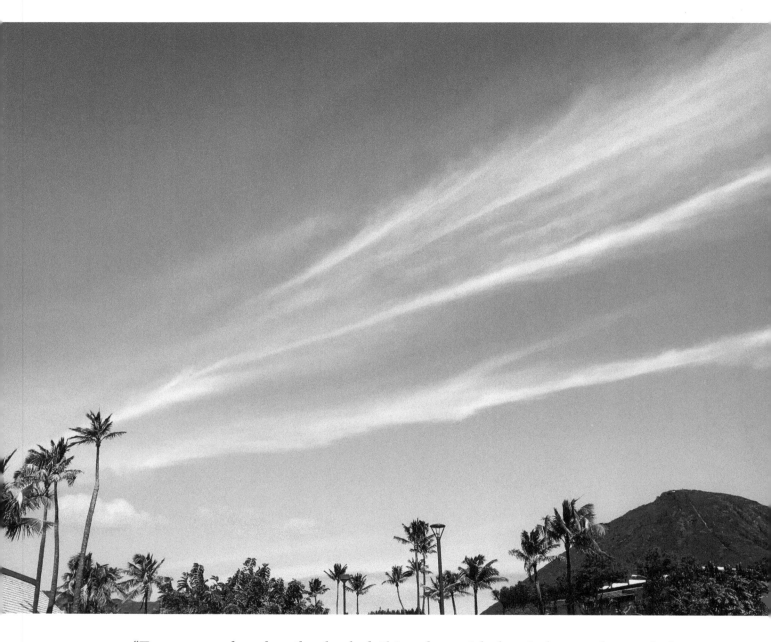

"There came a day when the clouds drifting along with the wind aroused a wonderlust in me, and I set off on a journey to roam along the seashores." Matsumoto Basho

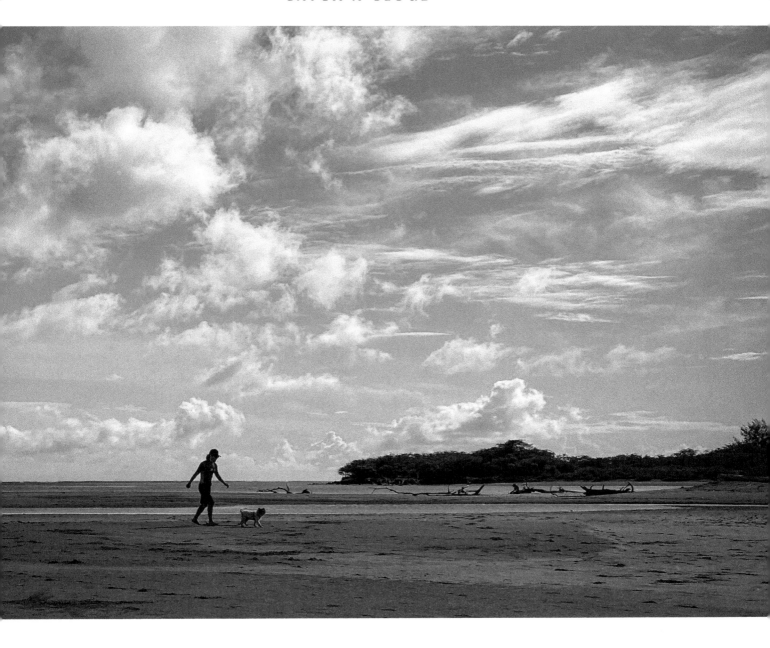

"I walk alone with the clouds moving along with me bringing me joy." Janice McEwan

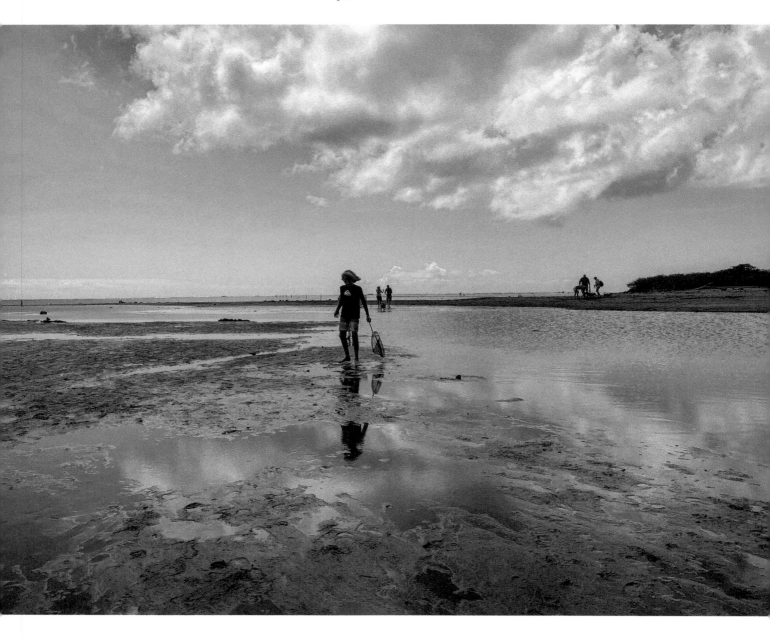

"I returned today to catch my cloud." Janice McEwan

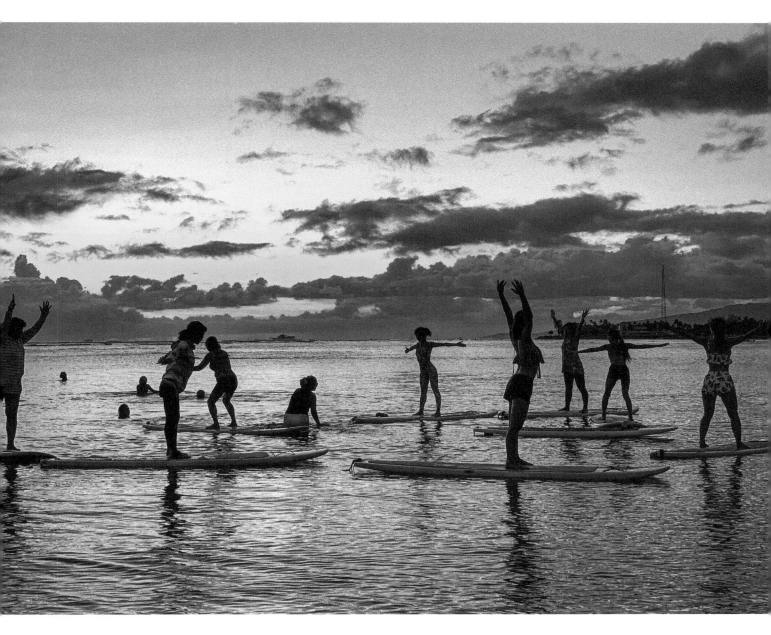

"Catch a cloud." Janice McEwan

ABOUT THE AUTHOR

Janice McEwan, a retired English as a second language resource teacher, has lived her passions since retirement. When she isn't outside taking photos with her iPhone, she is searching for or writing quotes to use as captions for them. She posts on Instagram and Facebook and is a member of the Eyes of Hawaii photography club and a former member of the Electronic Social Art Forum, ESAF, based in France. In 2012, one of her edited iPhone photos was selected to be displayed in France at the ESAF Exhibit. She has also exhibited several iPhone photos at the Eyes of Hawaii artists' Exhibits. A native of Pennsylvania, she has lived in Hawaii for fifty-three years.

CPSIA information can be obtained
at www.ICGtesting.com
Printed in the USA
BVHW021229280222
630222BV00016B/495

9 781665 717342